THIS JOURNAL BELONGS TO:

FALL

WINTER

SPRING

SUMMER

AND ONCE AROUND AGAIN

Nikki McClure

REMEMBER
A Seasonal Record

SASQUATCH BOOKS
SEATTLE

Jump in leaves
Forage for fallen fruit
Bake two pies
Gather nuts
Plant garlic
Can applesauce
Dream up new soups
Wear a scarf
Eat squash
Identify mushrooms
Save seeds
Wear socks
Rake neighbor's leaves for compost
Drink pots of tea
Hunt for ghosts

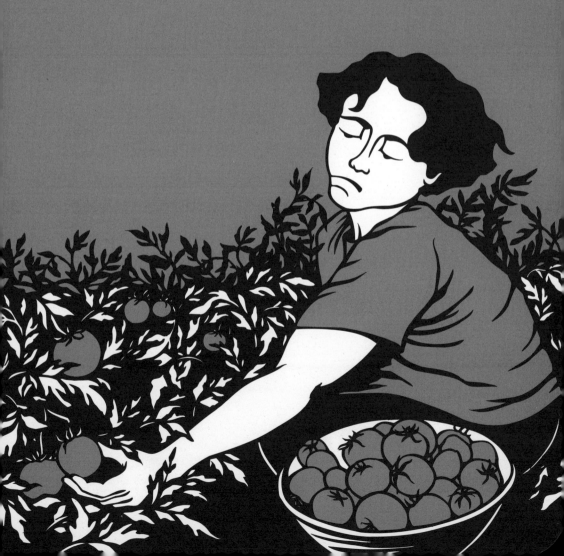

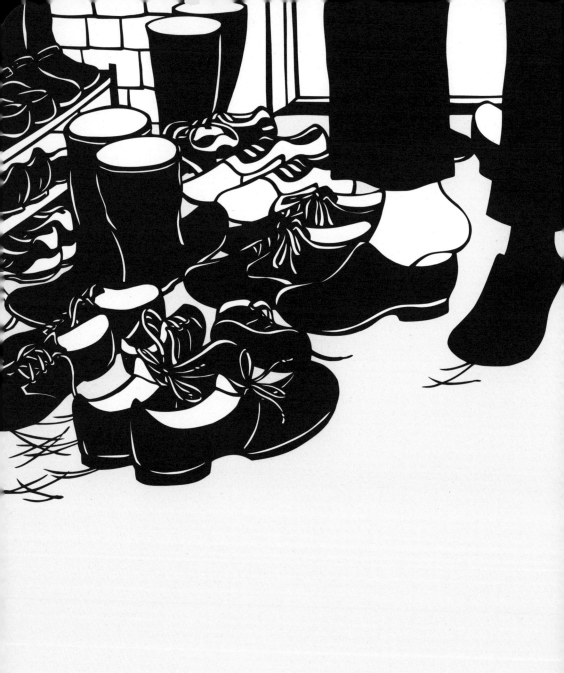

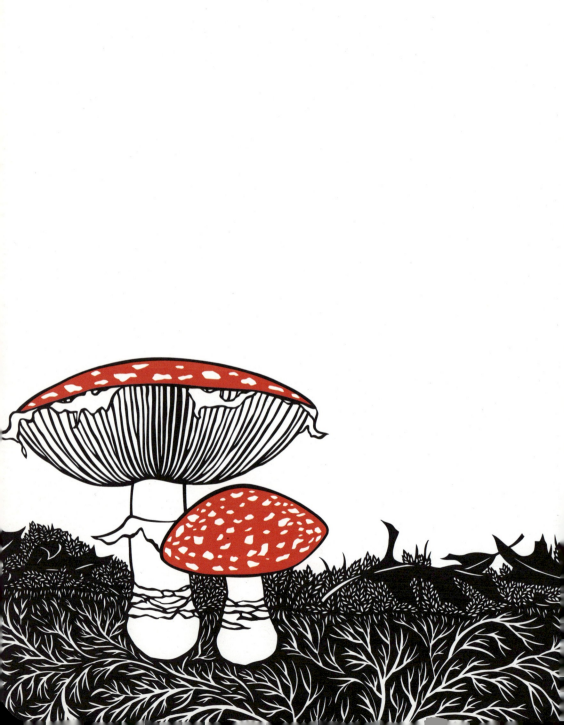

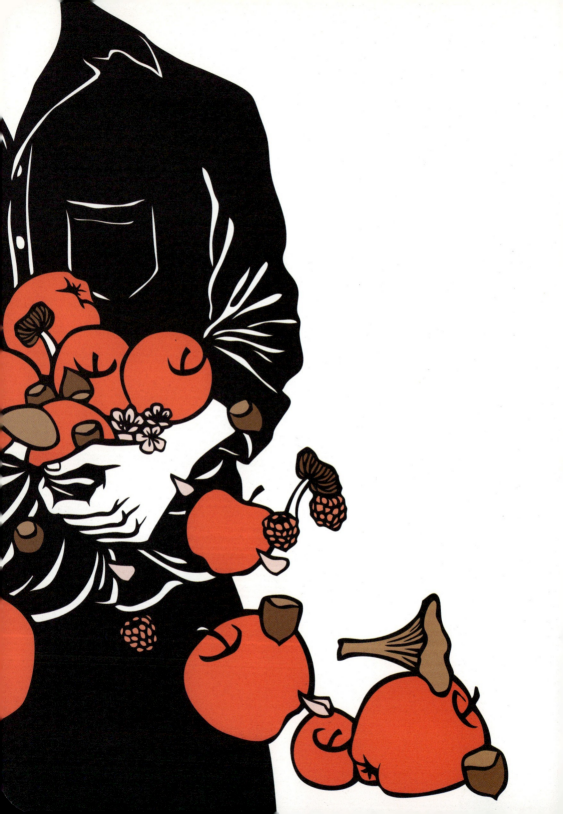

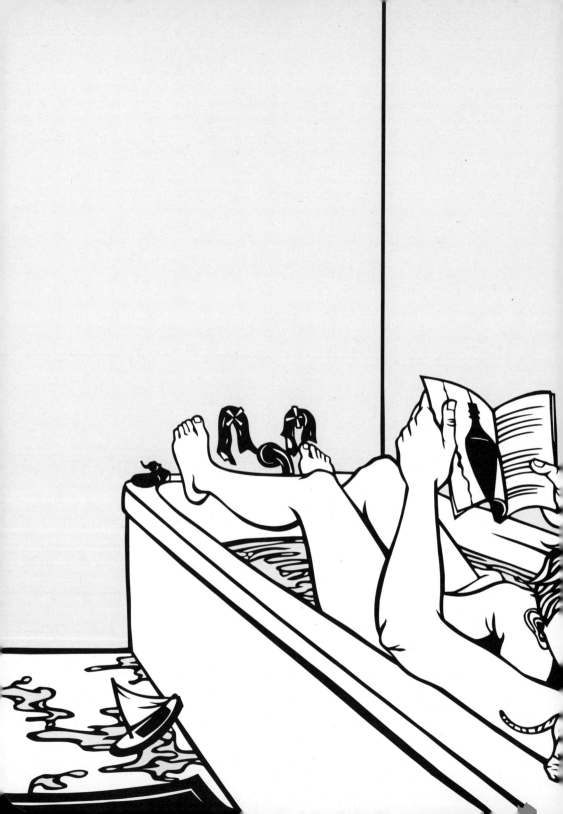

Build a fire

Eat with friends

Go to the library

Walk at night

Have a sauna salon

Make friends with the neighbor's cat

Read cookbooks

Eat kale

Sleep in

Barter

Make tamales

Heat it

Follow raccoon tracks in the morning snow

WINTER

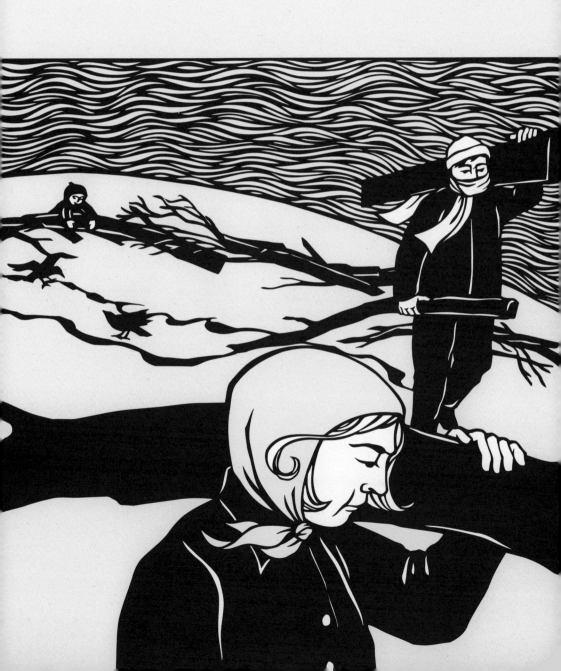

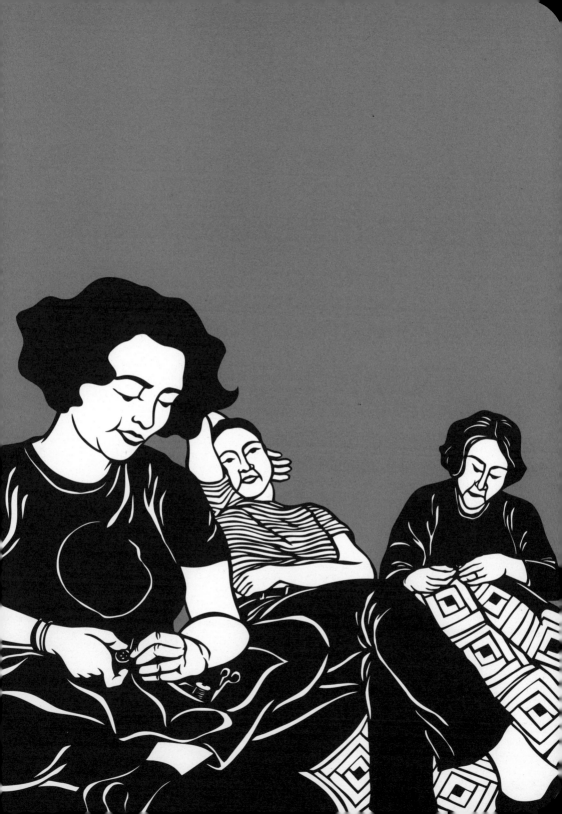

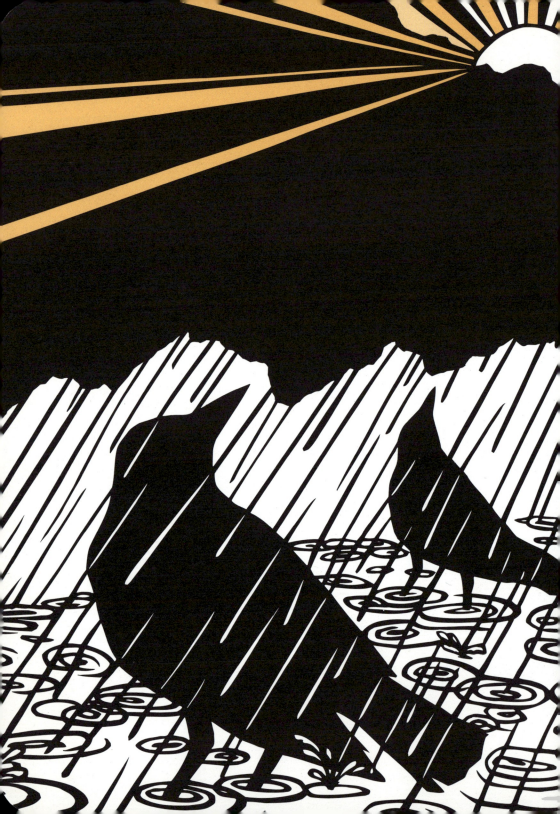

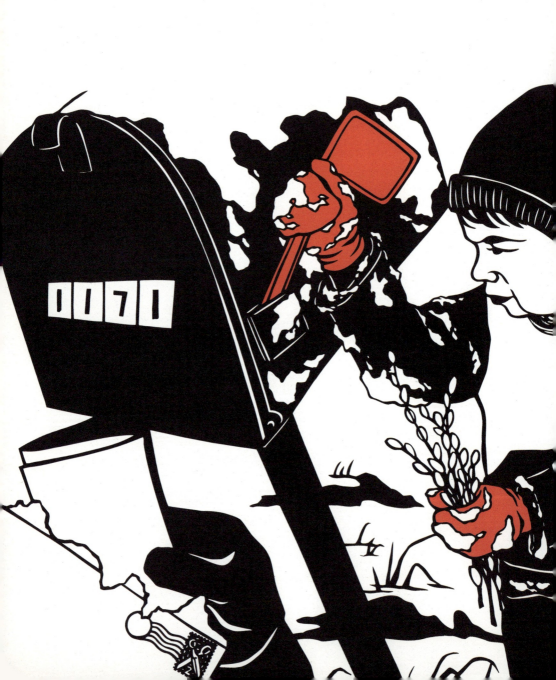

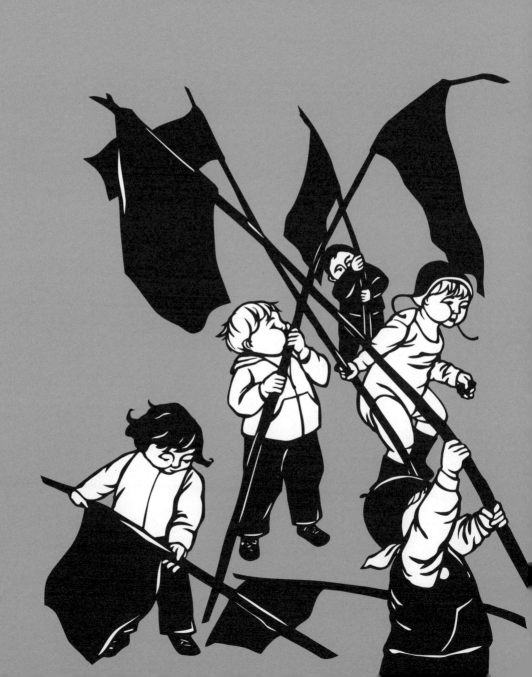

Wake up early

Dig

Check rubber boots for spiders

Oil the wheelbarrow

Balance an egg

Eat nettles

Hide

Visit Grandma

Bring tarp on picnic

Clean out freezer

Get the mail on barefoot

Dry clothes outside

Plant seeds

Sing with the birds

Climb

Pollinate fruit trees

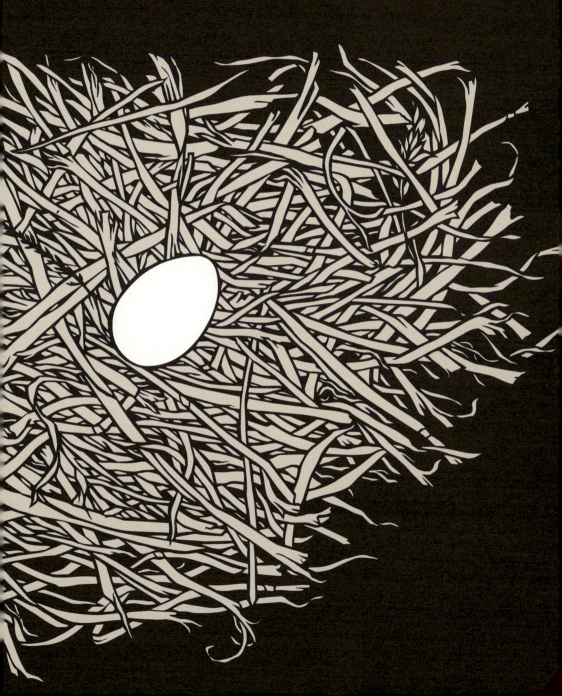

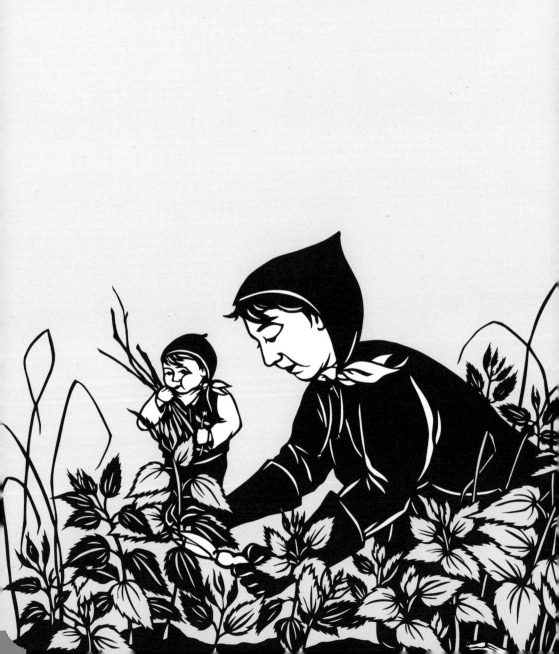

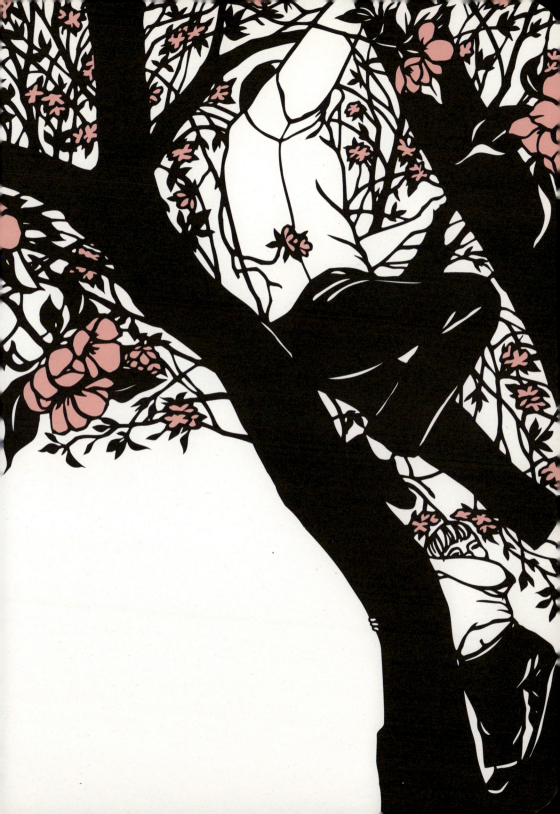

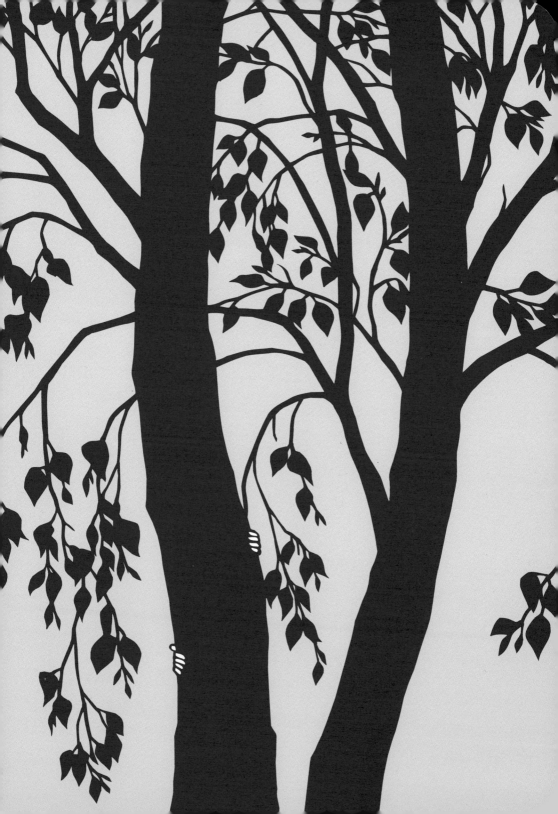

Build a Bedouin tent
Throw a party
Go barefoot on a forest trail
Tell bad jokes all night
Sing songs to friends
Watch meteors fall
Make ice cream
Share a secret swimming spot
Float
Bike everywhere
Never go inside
Pick pick pick pick pick
Wash windows
Dry mint for winter tea
Swim at night naked
Be buried in sand

SUMMER

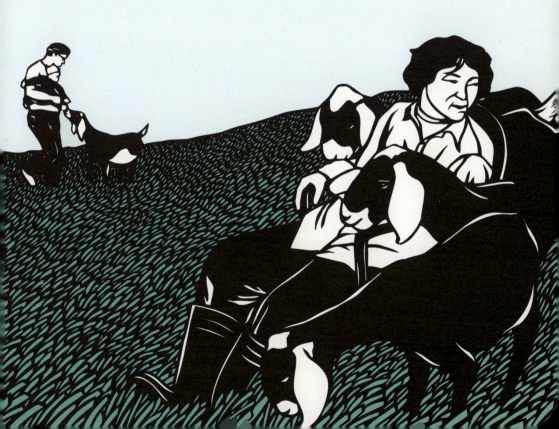

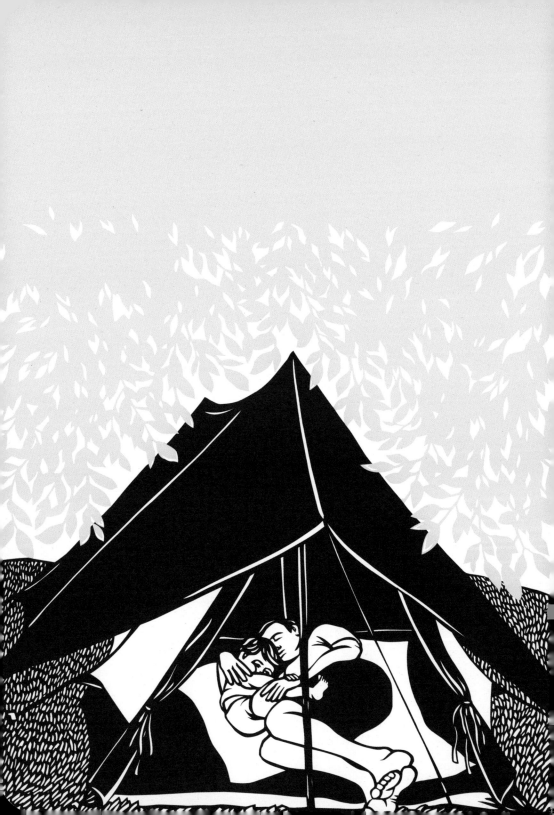

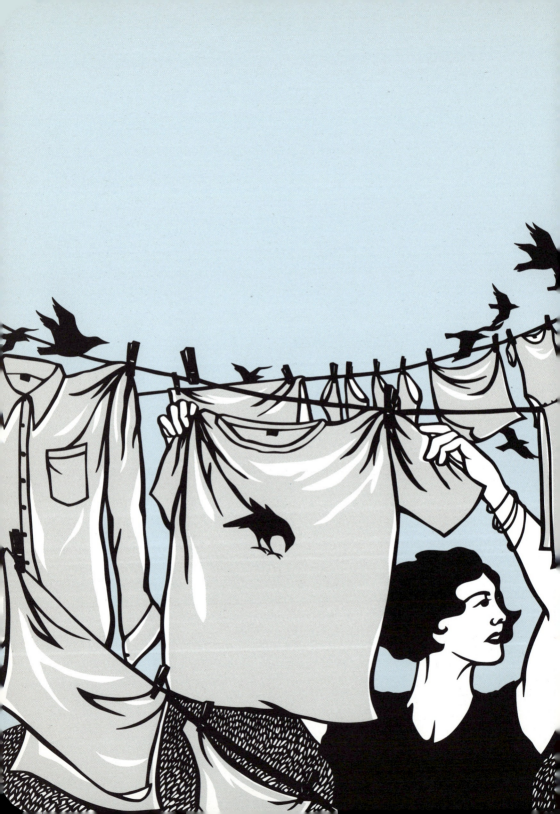

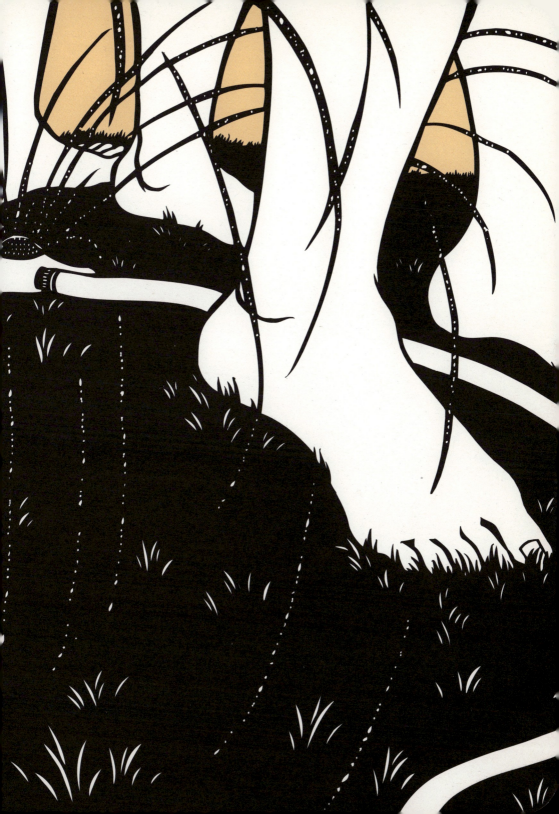

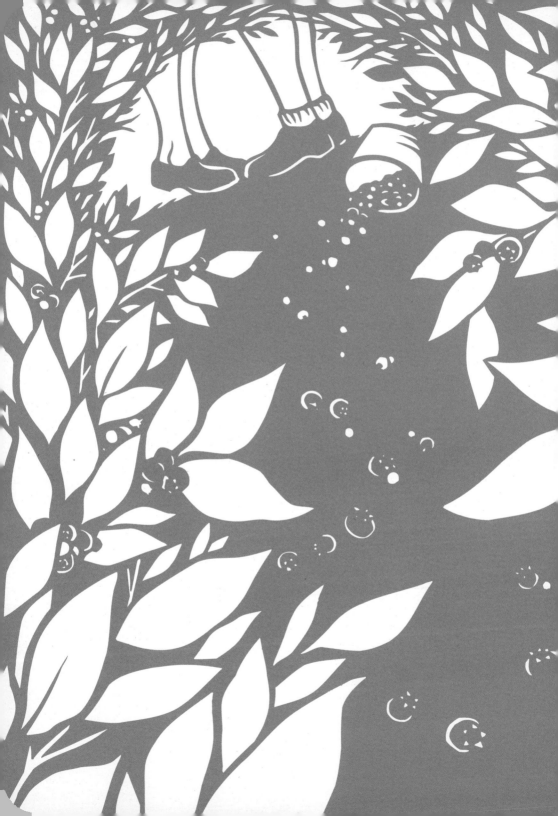